Mark Elsen's

Art

Book

©2016 Mark Elsen

All rlights reserved

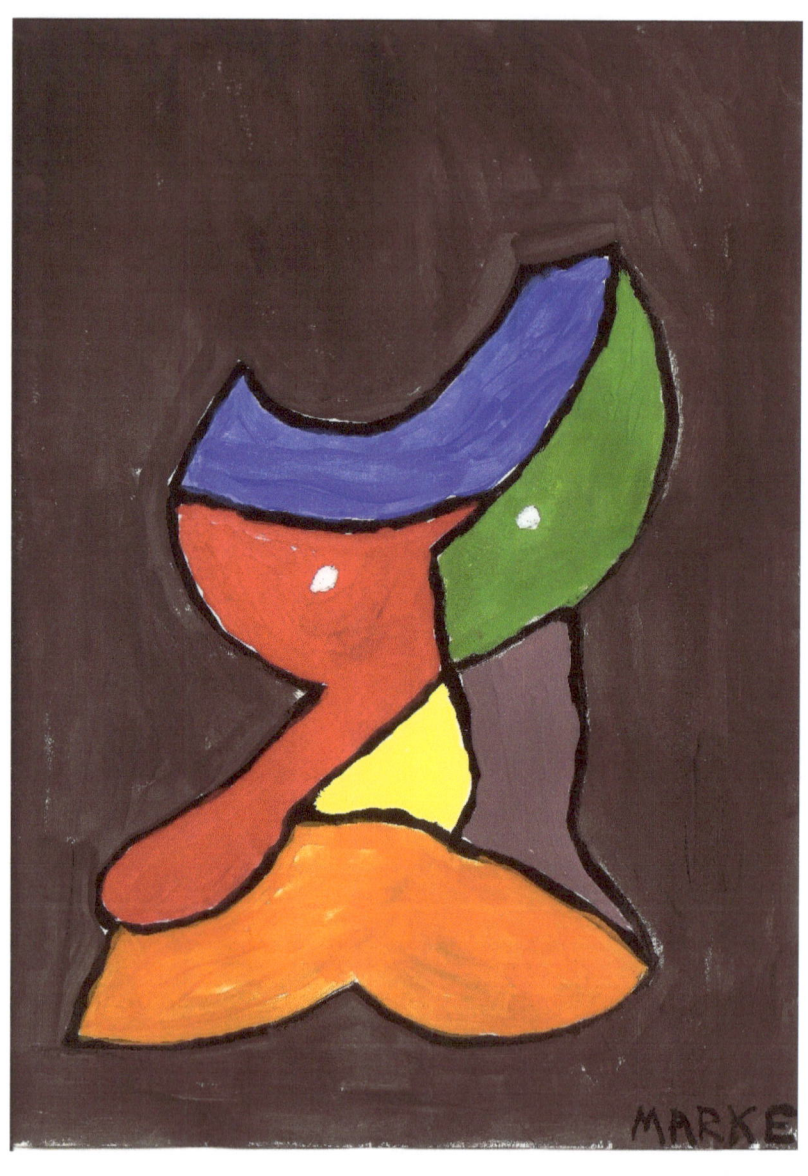

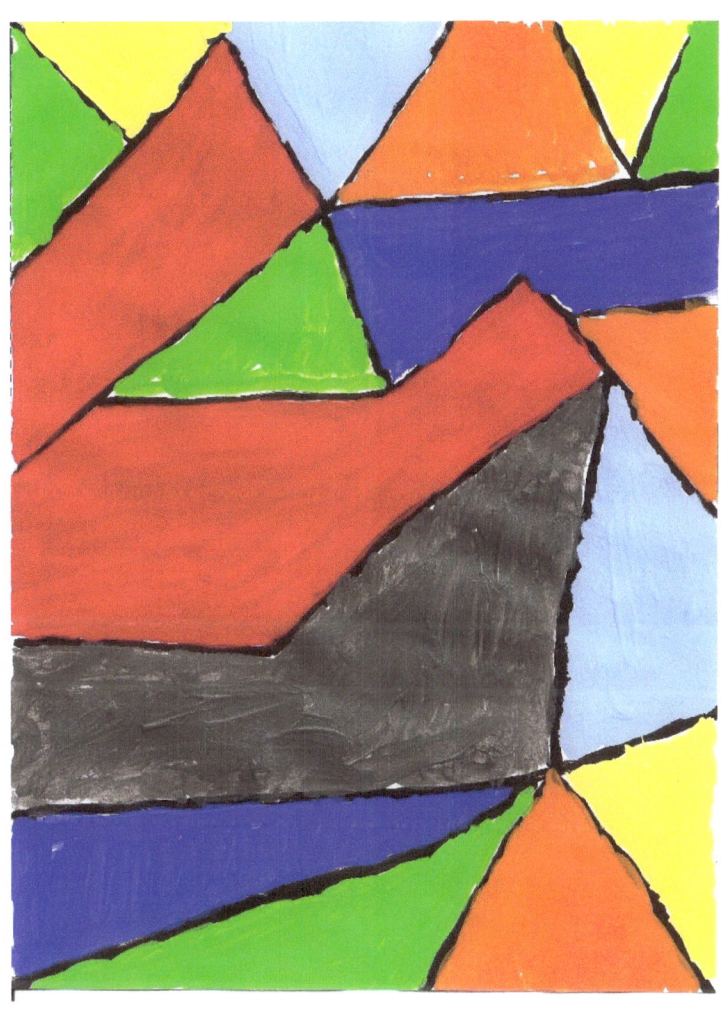

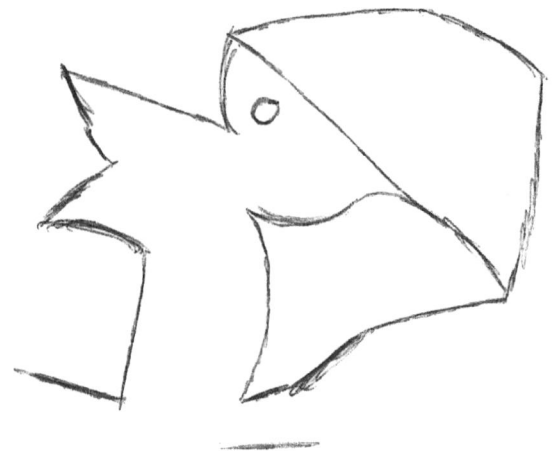

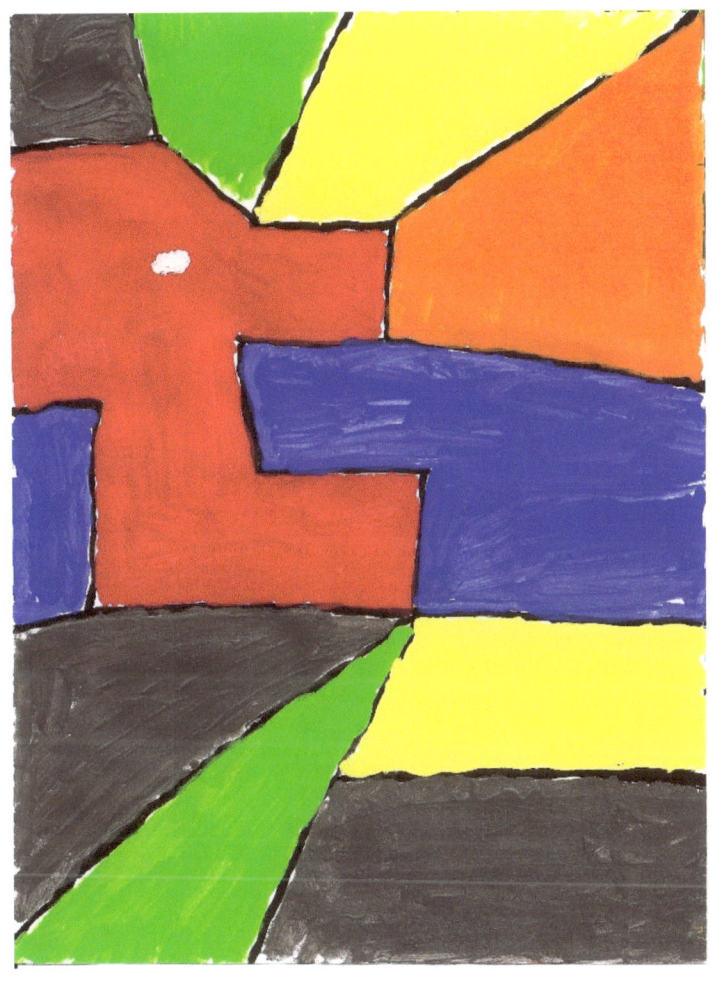

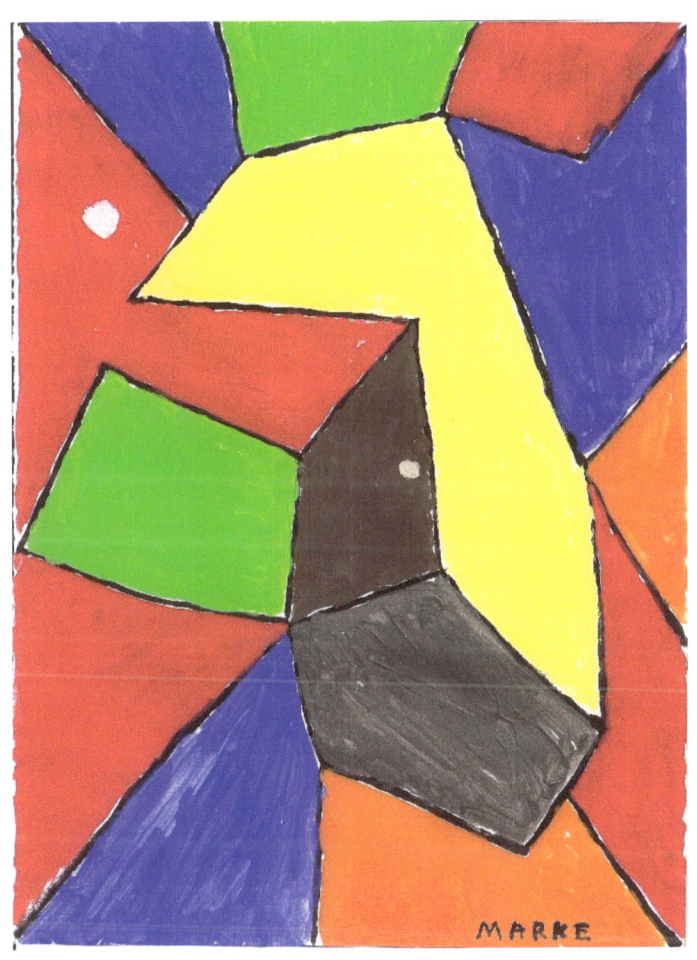

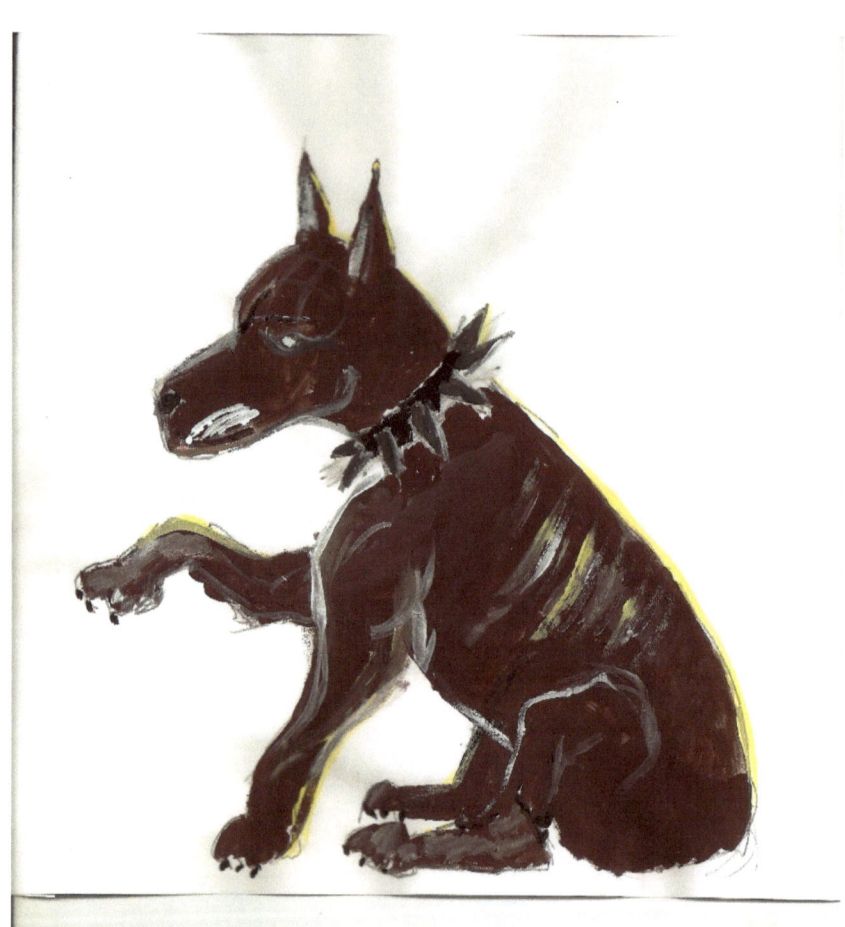

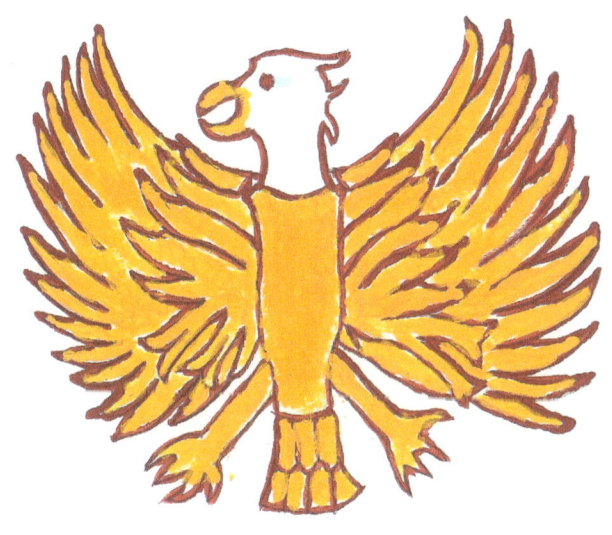

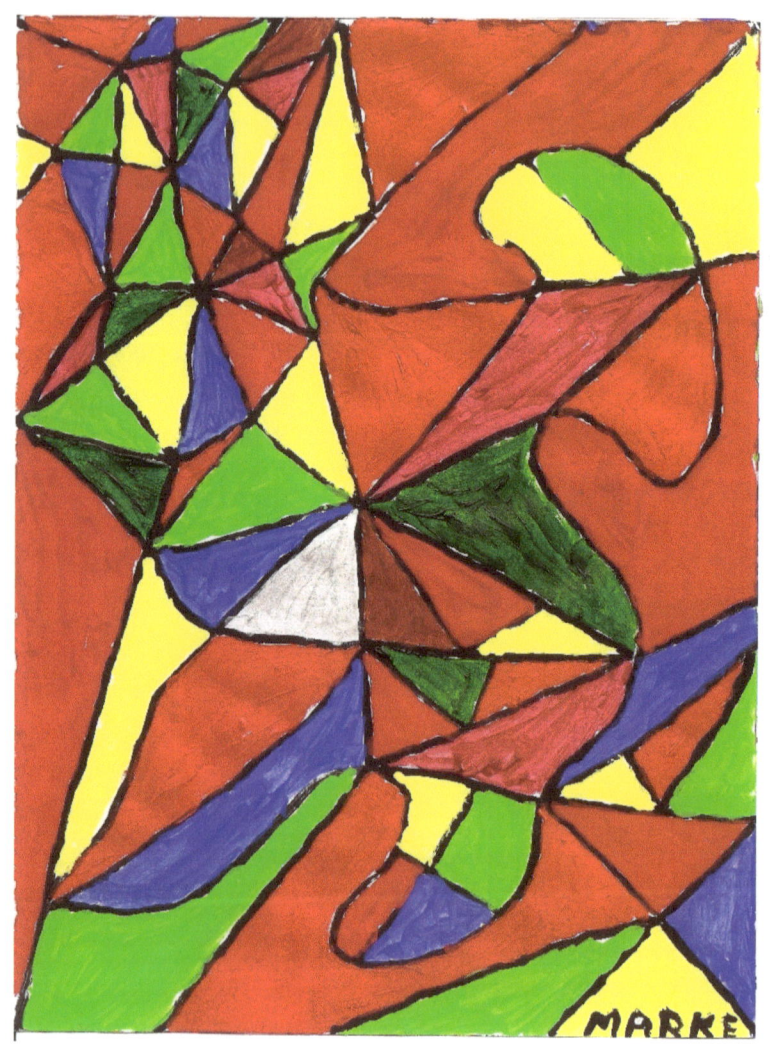

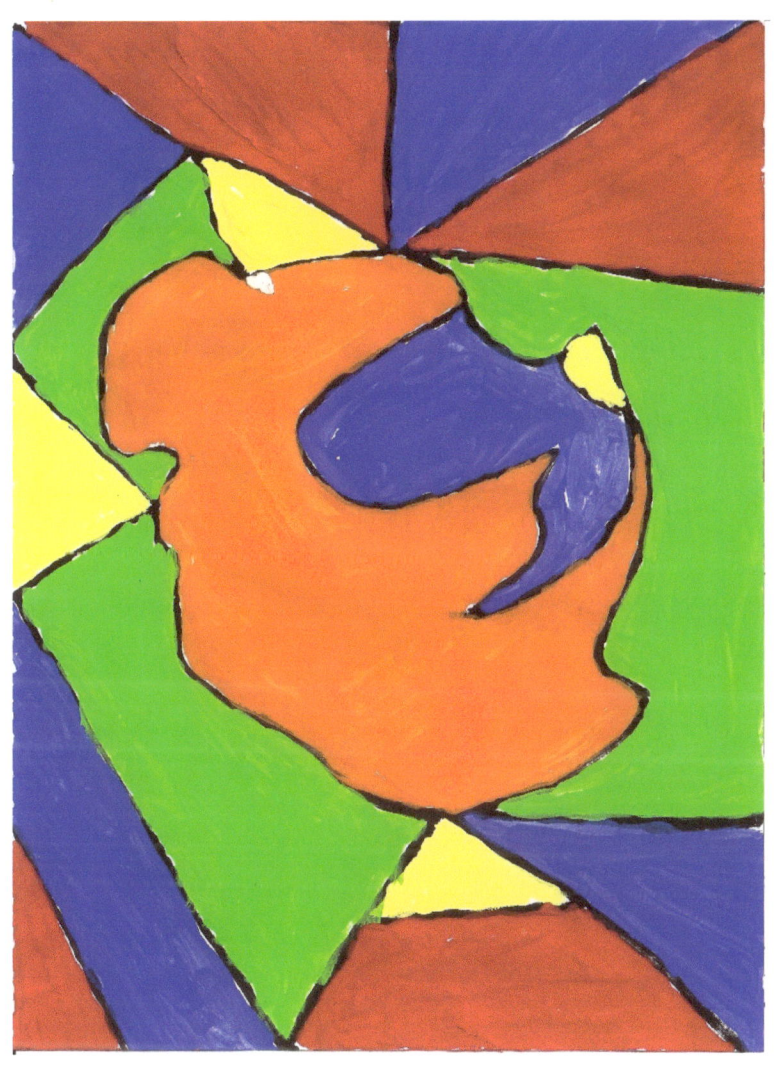

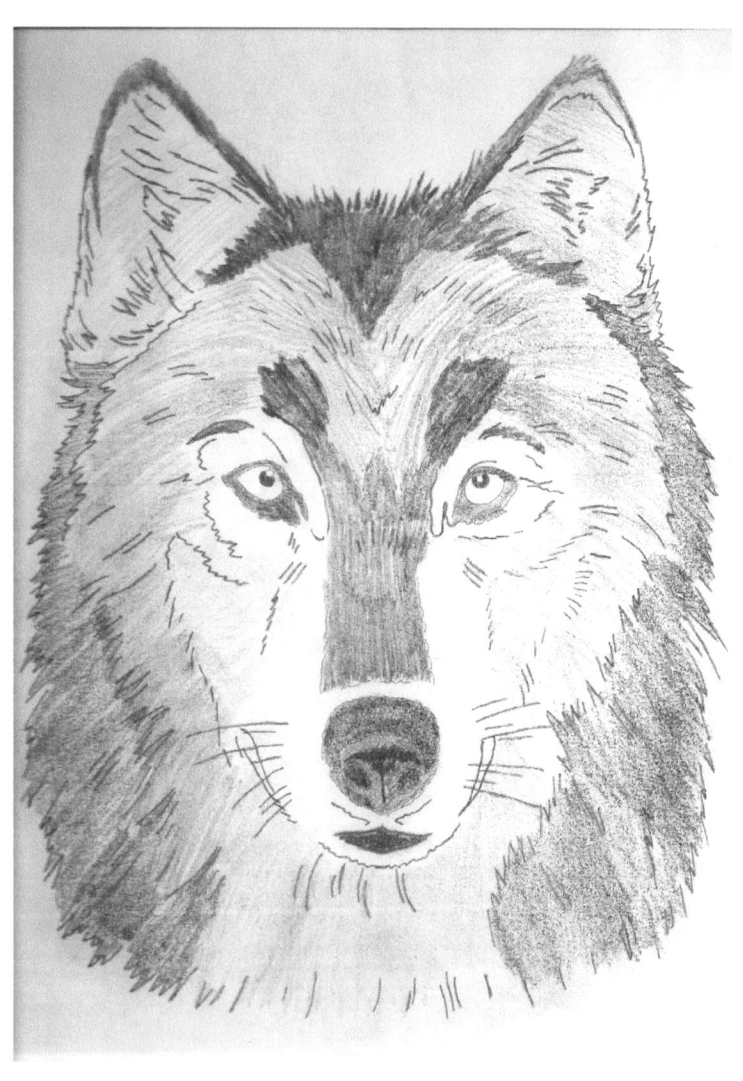

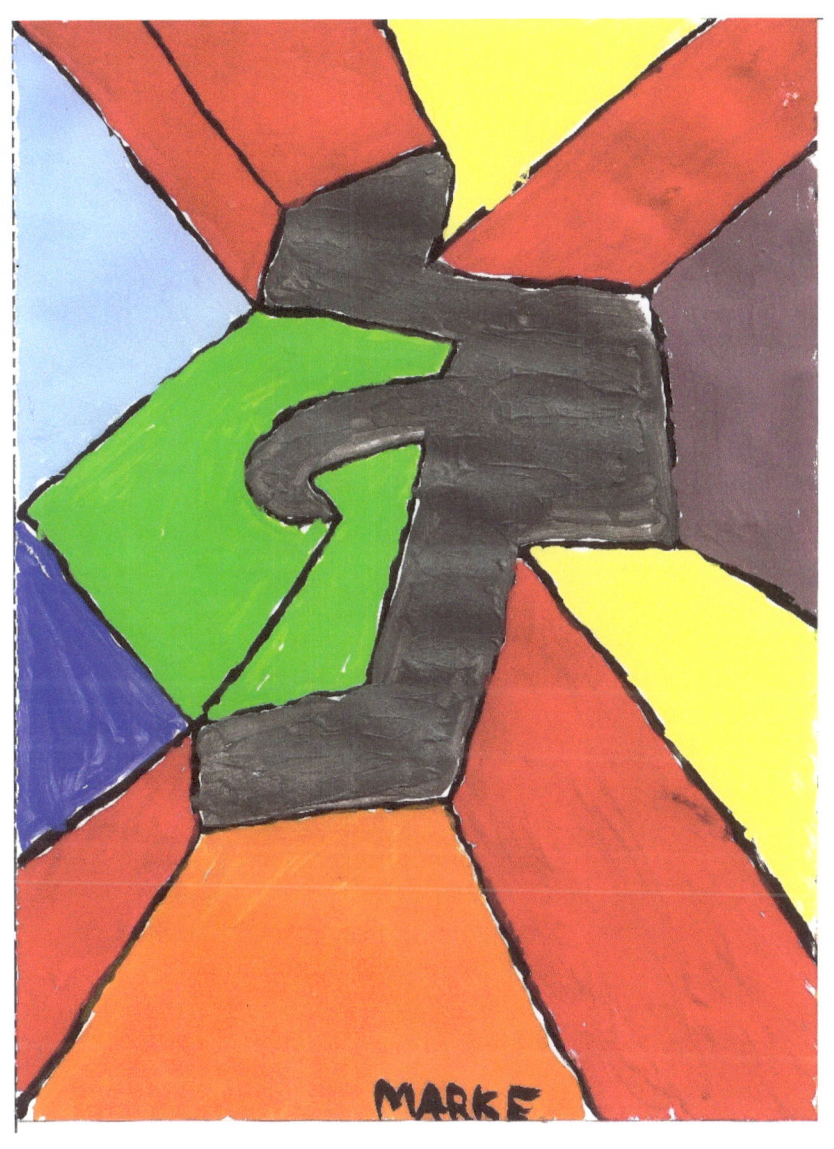

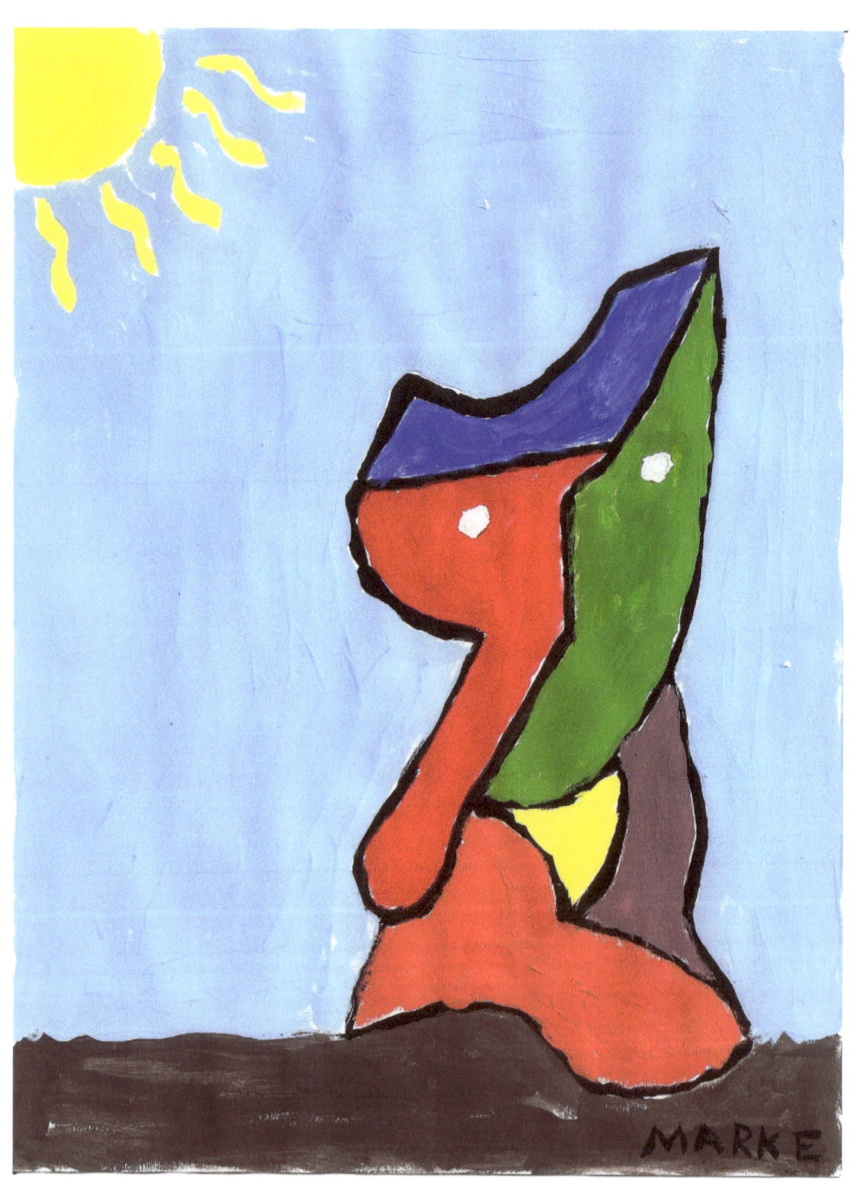

THE WOLF THE SHARK THE BEAST

Mark Elsen

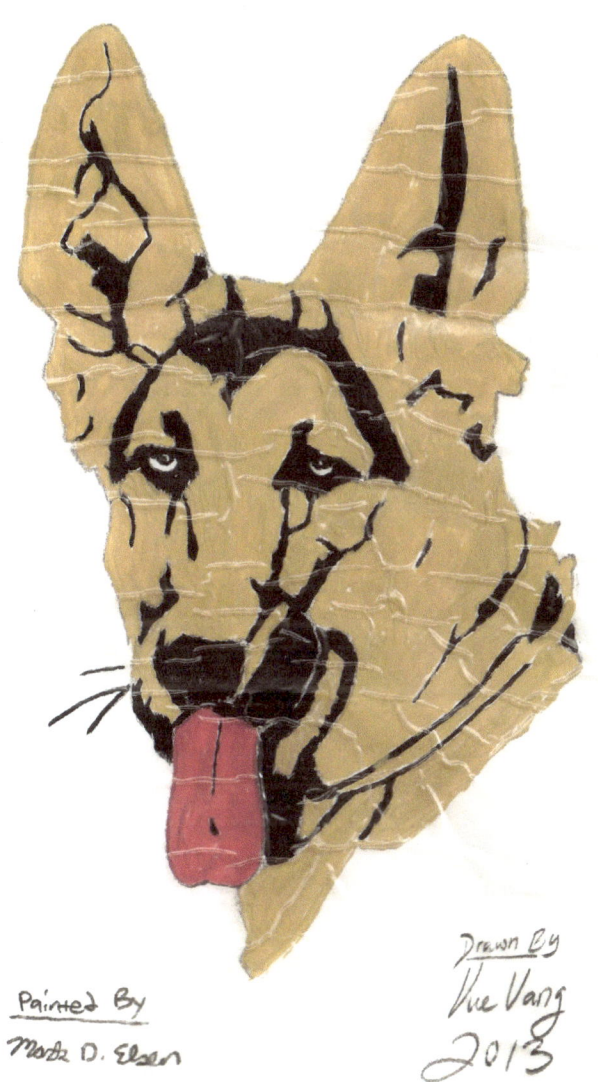

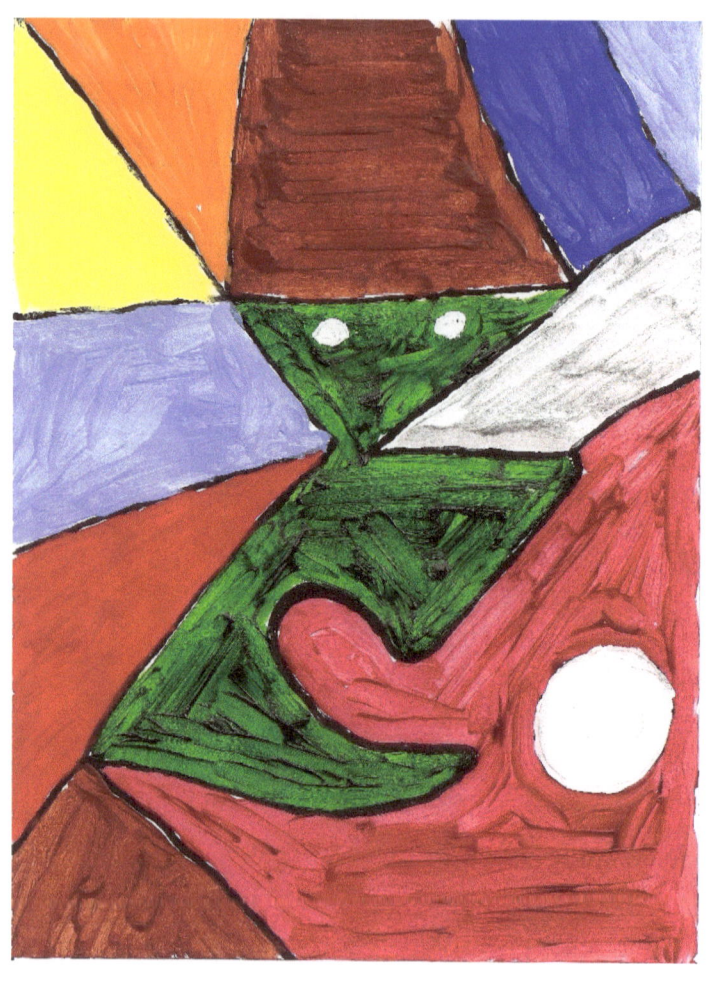

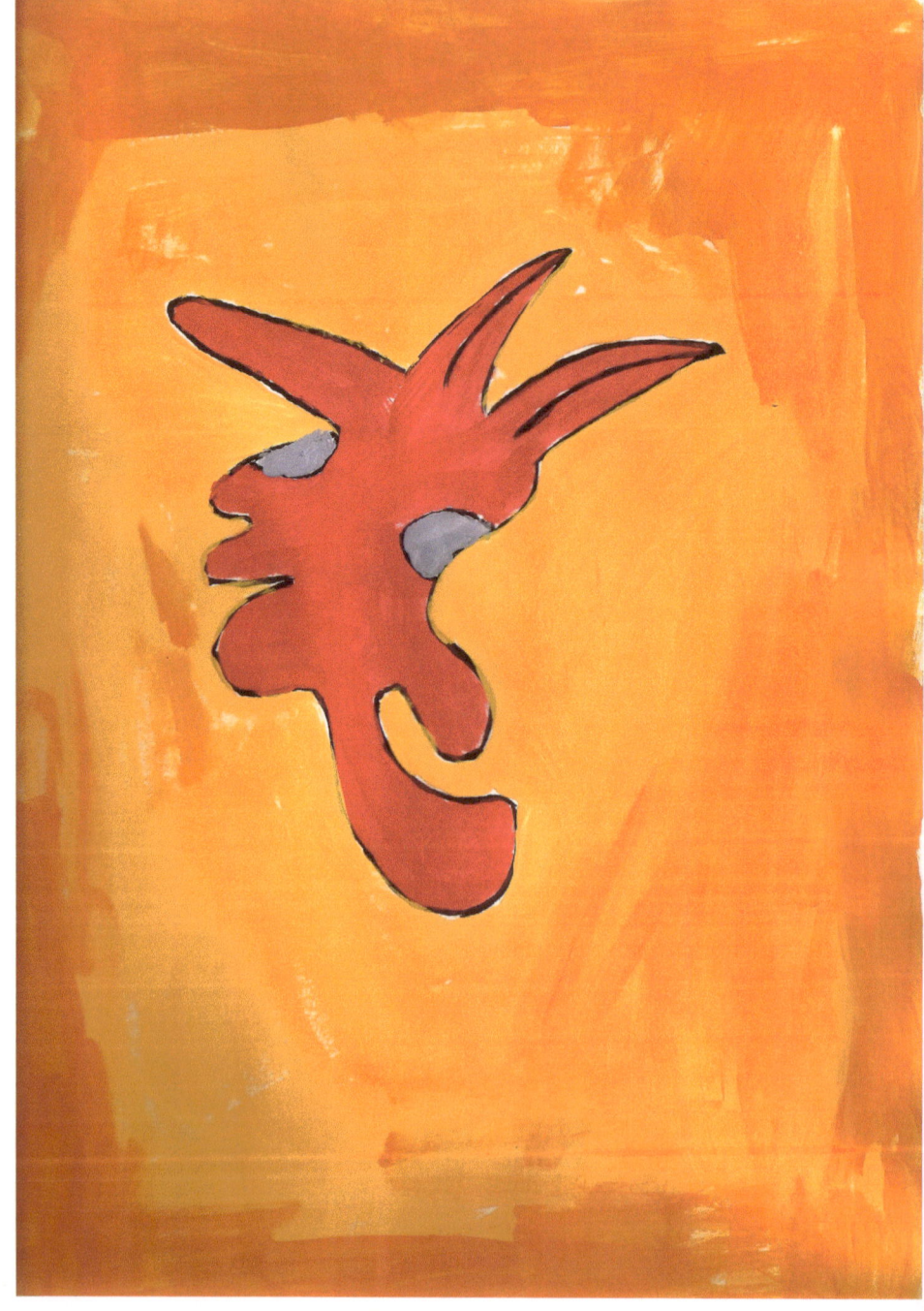

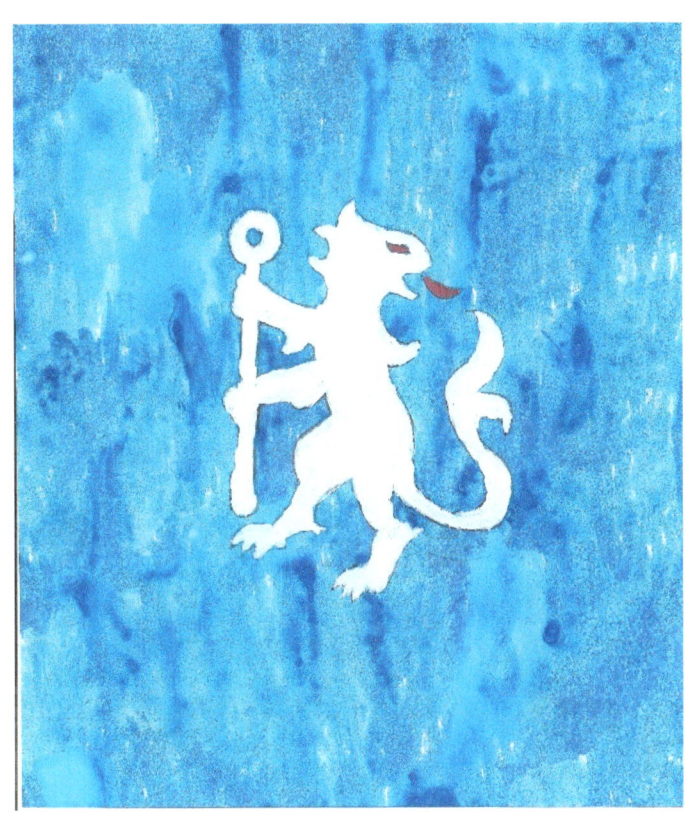

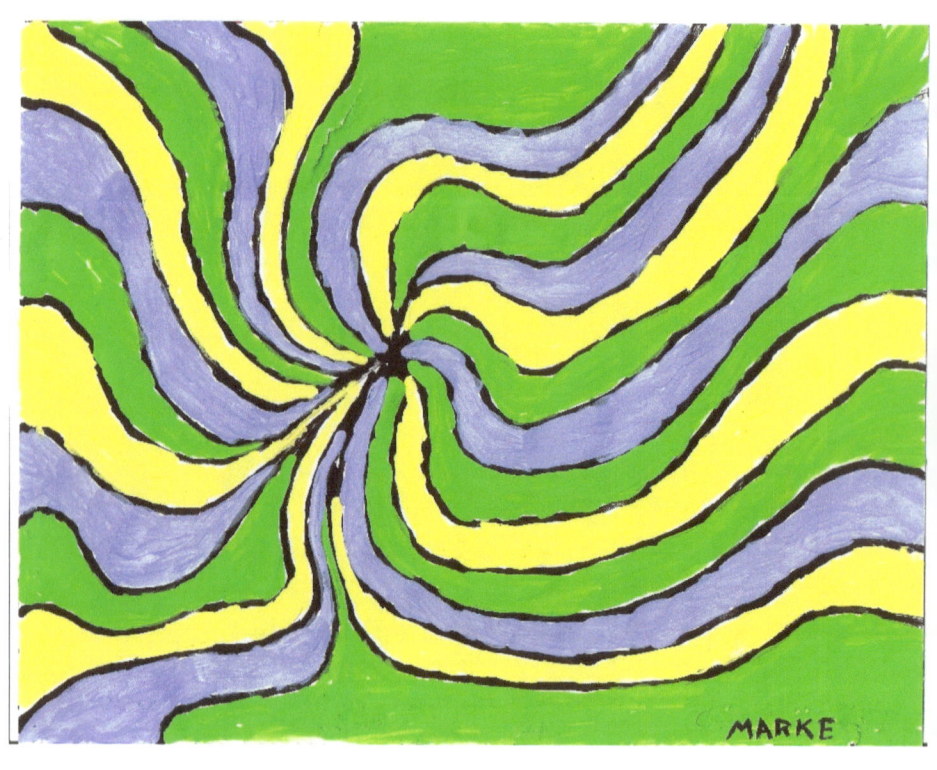

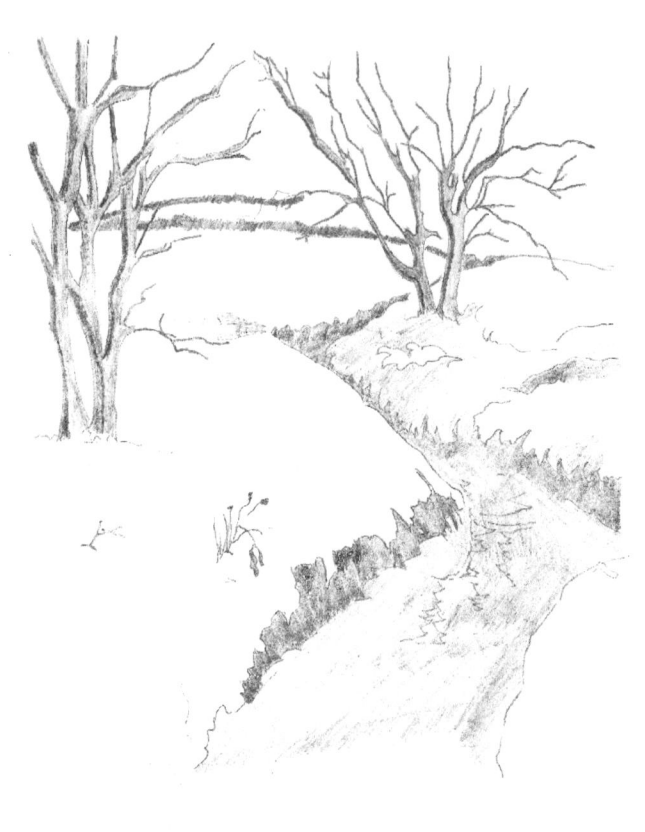

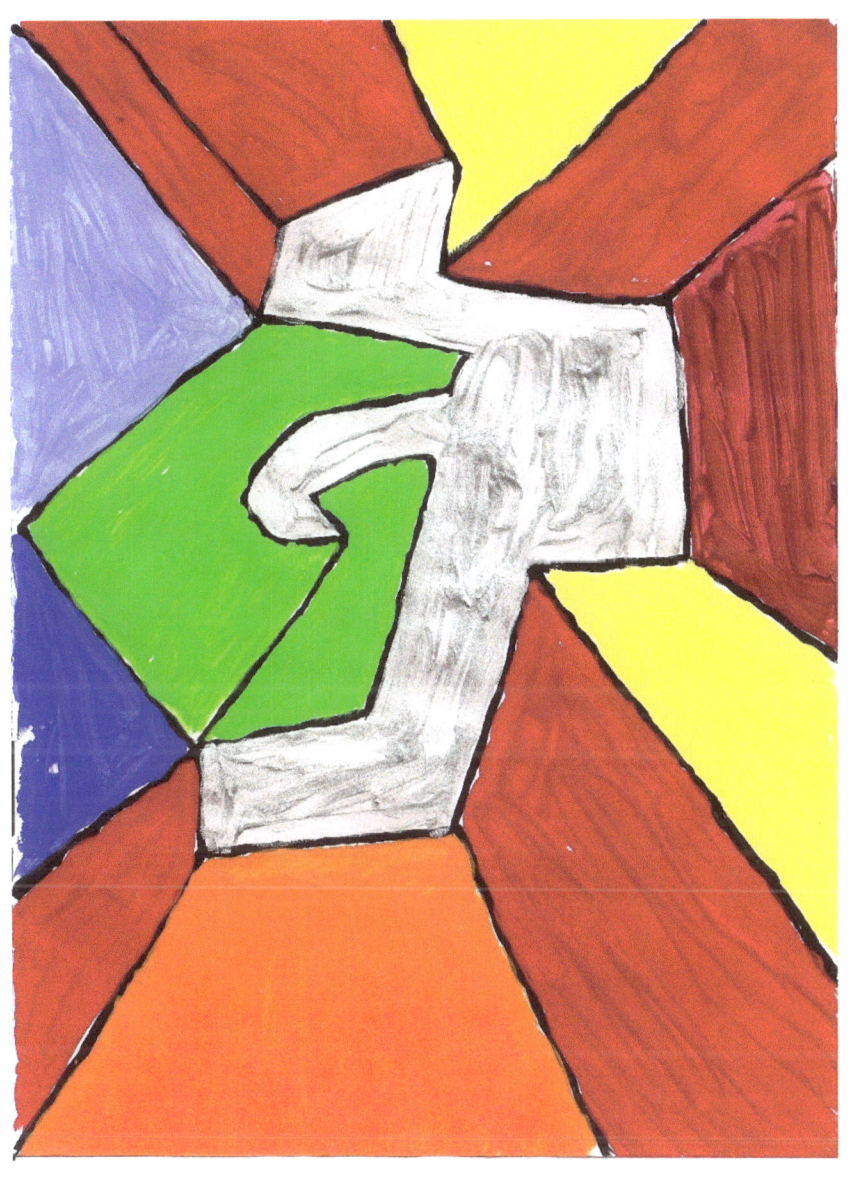

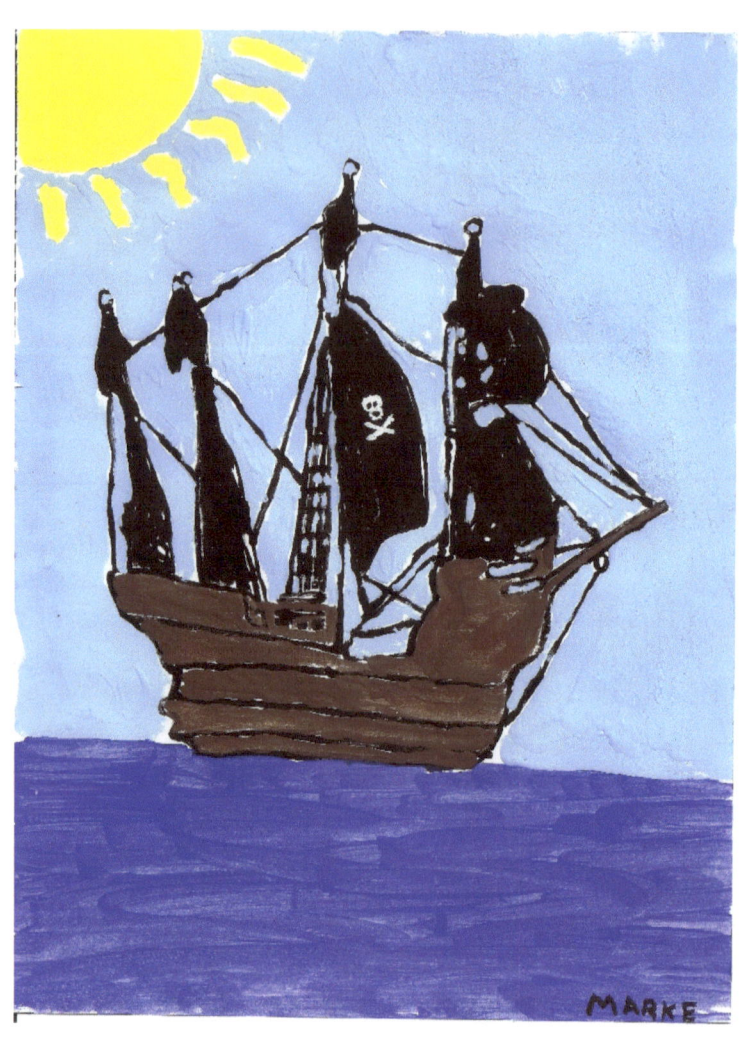

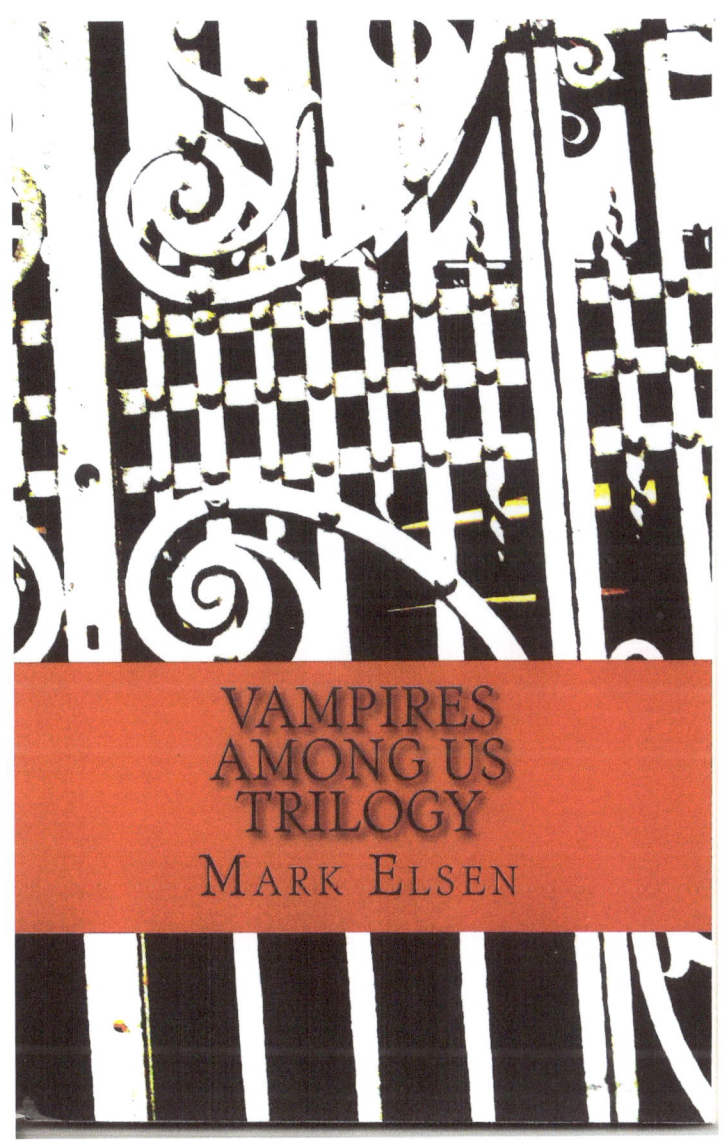

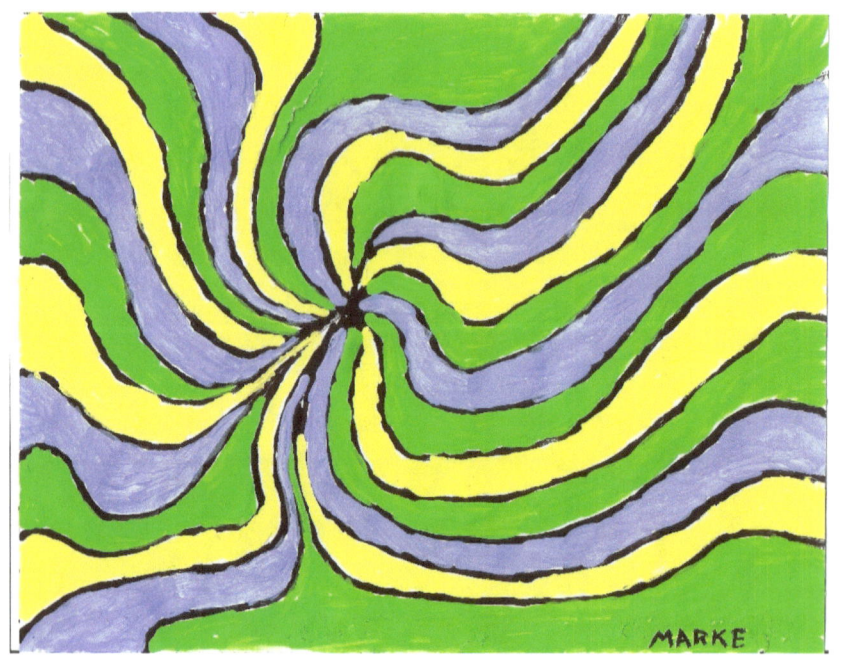

www.ingramcontent.com/pod-product-compliance
Lightning Source LLC
Chambersburg PA
CBHW041614180526
45159CB00002BC/854